A Guide

TO THE

Scientific Knowledge

OF

Things Familiar;

BY

Johnny Damm

**Carefully Revised, and adapted for use in Families
and Schools in the United States**

Brooklyn, New York
The Operating System
February 2017

the operating system print//document

SCIENCE OF THINGS FAMILIAR

ISBN 978-1-946031-03-7
Library of Congress Control Number 2016962665

copyright © 2017 by Johnny Damm
edited and designed by Lynne DeSilva-Johnson

For additional questions regarding reproduction, quotation,
or to request a pdf for review
contact **operator@theoperatingsystem.org**

This text was set in Steelworks Vintage, Bodoni, Minion, Franchise, and OCR-A Standard, printed and bound in the USA, and distributed to the trade by SPD, with ePub and POD via Ingram.

THE OPERATING SYSTEM//PRESS
141 Spencer Street #203
Brooklyn, NY 11205
www.theoperatingsystem.org
operator@theoperatingsystem.org

FOR DANA AND DJUNA

FIVE DIAGRAMS

Fig. 442. Diagram of Your Breath

Fig. 241. Diagram of Your Touch

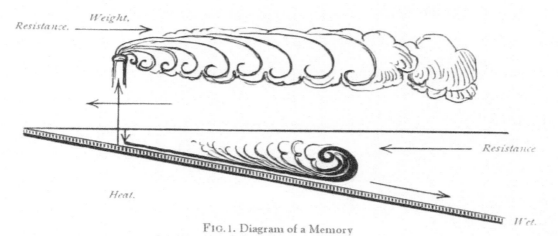

Resistance. *Weight.*

Heat.

Resistance

Wet.

Fig. 1. Diagram of a Memory

Fig. 5. Diagram of an Argument

You: W, E, R, L, O
Me: S, N, R, A, G, P, Q, W

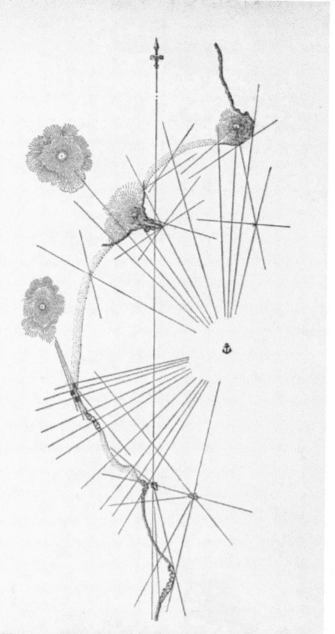

Fig. 16. Diagram of a Lost Day

1. BOOKS

THE OLD MAN'S ILLUSTRATED LIBRARY

ISSUE #10

ROBINSON CRUSOE

Daniel Defoe chops jalapeños. He slices longways, then

with his index finger, scoops the seeds from each half.

Nail scrapes flesh. His finger points the way, and the seeds follow.

Daniel Defoe doesn't realize that he's rubbed his eye

until the tears begin to fill his cheeks' crevices,

and the night itself begins to burn.

ISSUES #5 & #11

MOBY DICK

&

DON QUIXOTE

Herman Melville finds himself crying. To test a theory, he begins working through the times tables. Upon reaching the sevens, he checks back in to find that, indeed, the tears still come.

Herman Melville attempts to recall the previous moment. He gives up when he finds himself thinking of a film he'd once seen, one whose title and even actors he can't recall. All he's sure of is that the film featured a semi-truck and an orangutan. What the ape could have been doing in the truck escapes him, but the image itself is right there: huge teeth bared in grin, hairy arms thrown into the air as if firing pistols in celebration. The image terrifies him. And it has been appearing with greater frequency, particularly when he's trying to work or sleep.

Herman Melville, to banish the orangutan, thinks of Miguel de Cervantes. He'd read somewhere that the author began *Don Quixote* while in debtor's prison, and something about that soothes him. What could be better for a writer than being forced into a featureless box? That's how he thinks of it, in fact: the crook-nosed Spaniard encased in cardboard. Tape the box shut, and drop it at the post office. Once it has circumnavigated the earth twice, open the box again to find Miguel de Cervantes replaced by *Don Quixote*.

Herman Melville performs jumping jacks naked. It's a way of confronting every horror at once. He closes his eyes and feels the jerk of his flesh—starting with the subtle pull of his cheeks, then the sway of his arm flaps, then the bounce of his chest. Finally, the absurd flopping of his cock and balls. He concentrates until the rhythmic undulations feel natural. His sagging flesh could almost be the sea.

Herman Melville eats a reuben from the Jewish deli down the street. His clothes are back on, but dots of sweat still gather at his hairline. In the furthest iteration of his fear, he sits in the driver's seat of the semi-truck cab, and the orangutan sits in the passenger's seat. They don't look at each other. He steers the massive machine and tries to ignore the seething alien presence beside him. A glob of Russian dressing slides into his beard.

ISSUE #57

The Song
of
Hiawatha

Walt Whitman brushes his hair one hundred strokes.

Walt Whitman believes

he can sense the life

in his cup

of probiotic yogurt.

Walt Whitman considers with pleasure

the ridiculousness of the word "probiotic."

Walt Whitman practices spelling it, but the letters

instead form two words

he's heard used so often to describe Longfellow:

"America's Poet."

ISSUE #162

ROBUR
THE
CONQUEROR

Jules Verne can't remember his dreams.

He's sure that Honoré
de Balzac always
remembered his.

Someone once told him
that Balzac donned fresh
white robes and boiled
an enormous vat of coffee

before sitting down to
write each morning.

How many times, Jules Verne wonders, did Balzac have to change his robes?

ISSUE #36

Herman Melville takes a pill to help him sleep.

But all it does is flip the switch

Illuminating the corners of his eyes.

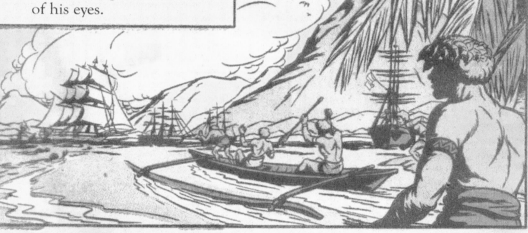

He rolls onto his stomach and the weight pushes into his already bloated gut,

As if his skeleton might burst from his belly button.

As if any moment now, free from follicle, fat, and sinew, his skeleton would begin to speak.

ISSUE #57

The Song
of
Hiawatha

Walt Whitman feels a sharp need to look out the window

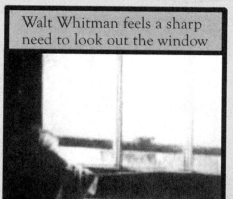

but pauses over the drawn back curtains

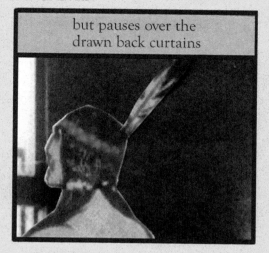

and rolls the sinewy fabric between his fingers.

There's a word for this, he thinks.

There's a word.

ISSUE #16

GULLIVER'S TRAVELS

Jonathan Swift runs a finger

over each tooth,

pausing at every

split, ridge, and chip.

Jonathan Swift lingers over
a single molar so long

that his mouth
fills with saliva,

causing the finger

to slip from its perch

ISSUE #162

Robur
THE
Conqueror

To Jules Verne, it often appears that the story
has been lost in its unfortunate headline:

Balzac's death from caffeine poisoning.

ISSUE #162

Robur
THE
Conqueror

ISSUE #11

DON QUIXOTE

The bedroom's only light comes from the flickering of a wireless router. Miguel de Cervantes slips a hand from under the covers and stretches unsteady fingers into the dark.

Eventually he manages to
synch his blinking with
the absent light.

ISSUES #36 & #5

Typee &
Moby Dick

Herman Melville wakes to the back of his neck burning.

He turns over,

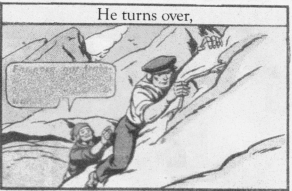

and the jag of light finds his eyes,

He raises a sheet over his head

only to be enveloped in the humid heat of his own breathing.

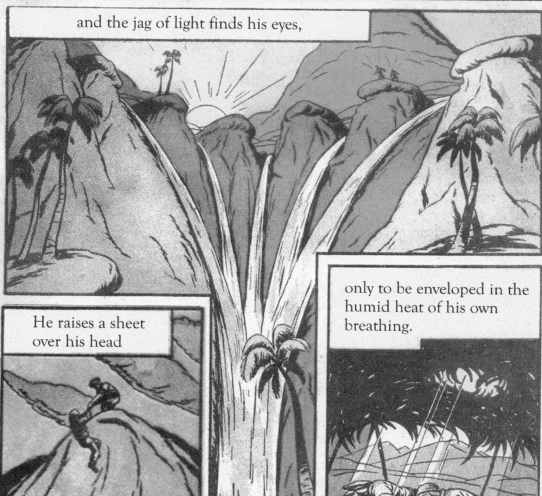

Herman Melville pulls down the sheet

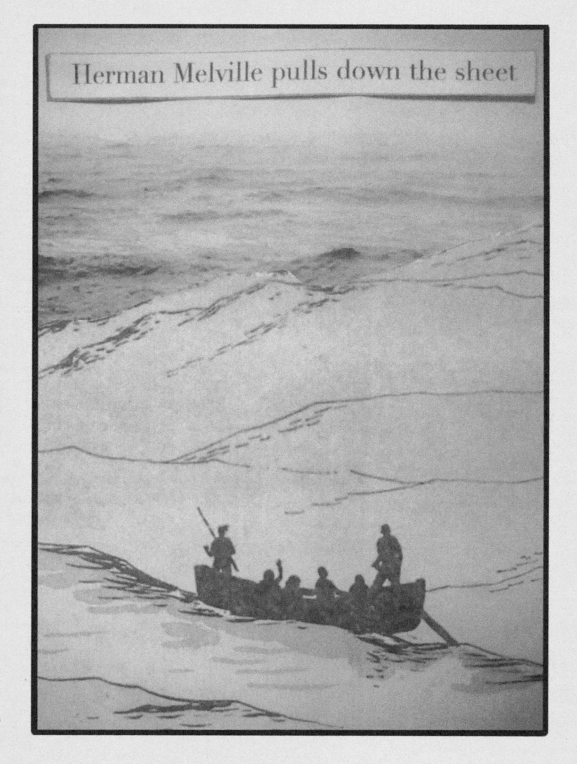

With a huff of effort.

the old man confronts the sun.

ISSUE #16

GULLIVER'S TRAVELS

Jonathan Swift
bites down.

ISSUE #162

Robur the Conqueror

Jules Verne regularly wakes to discover
yellowish spots splattered across his pillowcase,

despite the fact that he rarely drools
and unfailingly sleeps on his back.

Perhaps his bald spot is the culprit.

Perhaps his dreams are leaking out this way.

He seems to recall remembering his dreams when he had a full head of hair.

FOUR DIAGRAMS

Fig. 7. Diagram of the Three Directions
Our Evening Could Have Gone

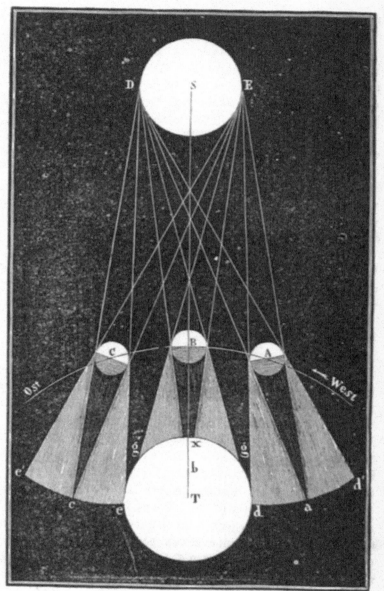

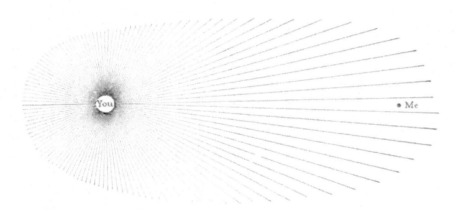

FIG. 12. Diagram of the Party (Relative Positionings)

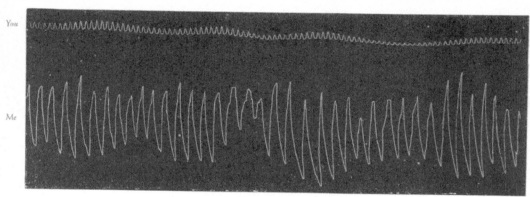

Fig. 33. Diagram of an Argument

Fig. 37. Diagram of How I Convinced You We Should Have a Child

1. FILM ENCYCLOPEDIA OF FAILED FILMMAKERS

I.

FILMOGRAPHIES

FILM

| 86 |

Anthony Mann
(1939–1968)

Even the back of Suzie's head is interesting. Someone once said that about Barbara Stanwyck in Anthony Mann's *The Furies*. I find Suzie, like Stanwyck, ugly right until the moment she crosses her legs in Billy Wilder's *Double Indemnity* and, like Fred MacMurray, I produce my most hardboiled swoon.

FILMOGRAPHY

Snatched from *The Streets of New York* (1939) by *My Best Gal* (1946) doing her *Strange Impersonation* (1946) of the fragile *Desperate* (1947) notes trilling my raw *Raw Deal* (1948). *Follow Me Quietly* (1949) she cooed, down this *Side Street* (1950) and through the *Devil's Doorway* (1950) just past *The Bend in the River* (1952) and into *The Last Frontier* (1955), where frogs *Serenade* (1956) every counterfeit Adam, every *Man of the West* (1958) mutely tending *God's Little Acre* (1958).

The Furies is *King Lear* in saddles, with a haughty Cordelia made center. In noir, the femme fatale is cast as foil, the catalyst for an unwitting protagonist's fall, an empty, if fabulous, set of lips, viscous curves for serpentine plot, but what happens when Stanwyck lingers too forcefully on the screen, asymmetrical eyes and improbable sexuality too fierce to cede corporeality? What happens then to the protagonist, to poor Fred MacMurray? The back of Suzie's head is the only garden this farm will ever see, so I plant my face in it and open mouth wide: Lear readying to rail against dark tendriled nature, MacMurray readying to sink teeth into Cordelia's perfect neck.

Douglas Sirk
(1934-1979)

FILMOGRAPHY

To New Shores (1937)! Suzie declared, while *I Lured* (1947) her to *Sleep, My Love* (1947). *Shockproof* (1949), she stormed out of bed with *Thunder on the Hill* (1951), and I asked ceiling, *Has Anybody Seen My Gal* (1952)? From bathroom, she demanded, *Take Me to Town* (1953)—*All I Desire* (1953) two rain barrels, canning supplies and a pack of tomato seeds, compost bin with red wiggler worms, end to the industrial food system, just a hint that this *Magnificent Obsession* (1954) isn't *All That Heaven Allows* (1955). Back in room, she crouched over me: *There's Always Tomorrow* (1956), breath on cheek, so *Never Say Goodbye* (1956). Can't you see the future *Written on the Wind* (1956), our *Battle Hymn* (1957) transcribed for Tarnished Angels (1957)? *A Time to Love and a Time to Die* (1958), my love, which do you choose? My cock stirred. My heart beat in perfect *Imitation of Life* (1959).

1. STREAMING VIDEO

"Loading," the screen reads, and we study the creep of red bars. One and Suzie stirs beside me, hiss released into the air. Two and her eyes turn to study the side of my poorly shaved cheek. Three and I don't turn to kiss her. Four and Rock Hudson appears. How have we come to this, perfect analog to imperfect digital? Or is it analogue, as in this analogue *All That Heaven Allows*, these ones and zeros curling through the air an uncoiling film strip that fills the bed we lie in? The blacks muddy in Jane Wyman's eyes, pixels reconstruct into Chuck Close squares. I can almost make out the ones and zeros, so I look for them on the side of Suzie's cheek. Rock Hudson in front of a window, while on the other side, a deer frolics in artificial snow.

2. TELEVISION AS GILDED CAGE

Bromide made explicit by Jane Wyman's reflection, caught eyebrows raised in the golden box wheeled in sparkling with Christmas ornaments, red bow, and even a card from her children dangling from the corner:

"Stay home, mother," it must read. "Wait for us, even when we're away. Whither fetchingly under iridescent glow."

3. A QUESTION OF NAMING

Leave it to Hans Sierk to offer a world where no one can picture Roy Scherer Jr. and Sara Jane Mayfield together, where even Agnes Moorehead suggests widow Jane Durrell watch television over Roy Fitzgerald stripping off lumberjack flannel. And only Detlef Sierk would have Rock Hudson quoting Thoreau, much less me quoting Hudson: "If you're impatient, you have no business growing trees." Surely eternally Agnes Moorehead—never Moorhead or even Morehead—can picture Jane Wyman in this Old-Mill-cum-Danish-Modern-Palace, lying next to Roc-cum-Rock, and reflected in the television screen, surely Suzie—never Suzy and rarely Susan—sees me lying next to her. Surely Douglas Sirk must show us the way.

4. AND ROCK
HUDSON APPEARS

Perhaps Suzie is the Rock. After all she
brought us here to this old farmhouse, this
old mill, and I am the Jane snatching broken
teapot from rough mill floor. I still call her
Roy, but she refuses me Sara. "Loading," the
screen reads, and our story is caught by the air
all around us. I bend, straining towards shards
of Wedgwood, while on the other side, Suzie
rises into ones and zeros.

NICHOLAS RAY
(1946-1980)

Something to do with on-set drinking, with Dennis Hopper hating him for hitting on sixteen-year-old Natalie Wood, with studying under Frank Lloyd Wright, gathering field recordings with Alan Lomax, making the best Bogart and Mitchum films no one remembers, with *I Was a Teenage Jesus*, really *King of Kings*, the bible as sixties bender starring dreamy Jeffrey Hunter, Robert Ryan as John the Baptist, certainly with the drug use of a much younger man.

In a Lonely Place tells all. Or perhaps *Rebel Without a Cause*. How about *Bigger Than Life*? American Suburbia stops James Mason's heart. Wonder drug saves him, turns him into the psycho there all along. You're tearing me apart, James Dean pleas with that gyrating collapsing quiver that makes millions want to fuck him, zip up red jacket and swallow head whole. Do you look down at all women, someone asks Bogie, or just the ones you know? How can anyone like a face like this? Bogie asks back. God was wrong, James Mason intones.

If I'm Johnny Guitar (lord let me be Johnny Guitar) then Suzie is Joan Crawford and America shrugs while the French worship our every moment, my suede jacket and sunken cheeks, Suzie's S&M cowgirl and endless eyebrows. As a human being, Ray once said, Joan Crawford is a great actress.

FILMOGRAPHY

Knock on Any Door (1949), Suzie warns and find *A Woman's Secret* (1949). Like frogs, *They Live By Night* (1949), evolution's chorus *In a Lonely Place* (1950) pastoral pop *Born to Be Bad* (1950), *Racket* (1951) to remind you're *On Dangerous Ground* (1952). As for the secrets of *Lusty Men* (1952)? Whisper *Johnny Guitar* (1954) with each furtive wank, *Run for Cover* (1955) when Suzie cracks the door, the only *Rebel Without a Cause* (1955) your *Hot Blood* (1956) a.k.a. *Bad Blood* (1956). *Bigger Than Life* (1956), *The True Story of Jessie James* (1957): he died mowing the lawn, *Bitter Victory* (1957) over indifferent green. Baby, can't we just play *Savage Innocents* (1960)? Here, corn might be *King of Kings* (1961) and *Wet Dreams* (1974) a reminder *We Can't Go Home Again* (1976), but can't dry kisses spark *Lightning Over Water* (1980)?

In bed, Suzie hands over a seed catalog, and I consider the percentage of our savings, the flickering remainder of what we really wanted to do here after all. If Wright gave him anything, Ray once said, it was the ability to see a film's architecture, the scaffolding beneath each choreographed gesture, the enframement of each spoken line. Orange Flesh Purple Smudge, Suzie declares. My tongue flicks to catch the words, shapes back, Molten Fire Amaranth. Suzie turns, Nipple Fruit, traces Gooseberry Gourd down my arm. Ideal Purple Top Milan. Brazilian Oval Orange. Cannibal Tomato. Bloody Butcher. Ananas Noire.

On Dangerous Ground

A title too easy, so I leave it with the nightly frog
chorus sagging over the countryside.

The love interest a blind girl, sister of the murderer
Robert Ryan hunts, played by Ida Lupino, herself a
director, 1952's only female director.

"Siberia?" Ryan asks of his new assignment.
"That's right," Chief answers. "Seventy miles north."

A three hour drive and we could reach Chicago,
seventy miles and a more modest Springfield.
I could reach out and touch a city, if it wasn't for this wall of
subsidy corn blocking the way.

"How do you live with yourself?" Ryan asks.
"I don't," Chief answers. "I live with other people."

Ray gives Lupino some nice close-ups, but Ryan's is
the face he really loves. Black-eyed, alien, beautiful,
you could pour petroleum down those crevices, slice
bread on that chin.

Former football star, now sadistic cop. Polished
loafer sinks into snow, snow seeps into silken sock.

Lupino shoulders the greatest load with the shortest
screen time: killer brother, perfect hair, blind, and
still the redemption Ryan so clearly pines for.

Suzie stands at the window and peers through
ammonia streaked glass. I stand behind, squint over
shoulder, but can't follow the action.

IDA LUPINO
(1949-1953)

The first thing to know is she's perfect. How else, in 1949, could a woman end up in the director's chair? Veteran B director suffers heart attack, supremely confident lead actress fills in. He's dead by the premiere, she's offered a melodrama within the month. The new film, *Never Fear*. The one she took over, *Not Wanted*.

Every film remains in the cloud somewhere, and underground, roots too remain unsevered. *The Hitch-Hiker* might be noir (Ananas?) but with a plot anything but labyrinthine: a single decision, let's pick up that thumbing psychopath, plunges middle class dilettantes deeper down to where dirt remains unforgiving, earth never forgets.

Must be what poison is for: getting at the root of things. Can rapture come and only take away the weeds? Her breath organic, her words locally grown: If I believed in God, I'd say we were doing God's work. For now we simply sit and watch the day's rushes: a breeze's repeated take, preening stretch of green.

FILMOGRAPHY

An Outrage (1950), natural thriller director boxed into Sirkian melodrama. Even her women's tennis picture, *Hard, Fast and Beautiful* (1951), works best as heist film, sports/ life/ husband stolen by Claire Trevor, femme fatale as showbiz mother. Survey the set, consult the storyboards. When Nick Ray went missing from *On Dangerous Ground* (1952), who do you think took over? Plant hoe and call action, *Hitch-Hiker* (1953) from another film. "How do you live with yourself?" Ryan asks. "I don't," Stanwyck answers. "I live with you." Opening scene filmed last. Beam flickers. Flecks of grain, a hair. *Not Wanted* (1949), I step into light.

II.

Twenty-One Essays on Alberto Cavalcanti

1.

"I must confess that I am the sworn enemy of synchronism."[1]

2.

In his section of the British horror anthology *Dead of Night* (1945), Alberto Cavalcanti directs the poignant story of a ventriloquist's thwarted love affair with his dummy. The dummy wants to break up the act, to end their decades old relationship. Now, whether this is a case of the ventriloquist having developed Norman Bates-style schizophrenia (*Dead of Night*, incidentally, predates *Psycho* by fifteen years) or the dummy having magically come to life is never explained in the film, and honestly, it's beside the point. What matters is that the ventriloquist becomes overcome with paranoia and jealousy, and this swiftly leads to his attempted murder of a rival ventriloquist, the man who he believes has taken his place in the dummy's affection. The murder fails; the ventriloquist ends up in prison.

When a well-intentioned prison psychiatrist reunites the former couple, the short film reaches its climax: the ventriloquist lunges for his dummy ex-partner and attempts to smother it with a pillow. Then he drops the dummy to the floor and mechanically kicks in its frozen, grinning face, until little more is left than a heap of whitish powder and the sliver of a painted eye. All told, the violence lasts maybe thirty seconds and ends with the ventriloquist catatonic. Blank-eyed and mute. Only months later, prone in his prison bed, does the ventriloquist again open his mouth. And the voice that emerges from between his chapped, battered lips? The dummy's.

3.

Why, Cavalcanti asks throughout his life, can't sound plus image be treated in the same manner as image plus image—the bringing together of disparate, even opposing elements in what Eisenstein, who suggested sound should be treated as another element of montage, refers to as "collision"[2]?

4.

The Brazilian director begins his career in France as an expat architect before becoming increasingly involved in the avant-garde film circles of Paris. He works with Marcel L'Herbier and Jean Renoir and, for his film debut, makes the experimental *Rien que les heures* (1926).

1 Alberto Cavalcanti, "Music Can Provide Only Interior Rhythm," *Atti Del Secondo Congresso Internazionale Di Musica* (Firenze: Le Monnier, 1940), 267.

Out here, you know everything is okay if the internet is still working. I've stopped checking the news.

2 Sergei Eisenstein, "The Cinematic Principle and the Ideogram," *Film Form Essays in Film Theory*, ed. and trans. Jay Leyda (New York: Harcourt Brace, 1949), 37.

What's rural Illinois if not the slow collision between St Louis and Chicago?

After the transition to the sound era, he abruptly heads to England, hired by John Grierson to join that country's governmental film division—under the auspices of the Empire Marketing Board then later, the General Post Office—ostensibly to make propaganda shorts in support of the Empire. After six years, he then leaves for the newly formed Ealing Studios, where he helps create and define what comes to be known as that studio's definitive Britishness, directing films such as *Dead of Night* (1945), *Went the Day Well?* (1942), and as a freelancer, *They Made Me a Fugitive* (1948). When, in desperate financial and creative straits, he returns to his home country, Brazil's film industry views him as distinctly foreign[3]: he lasts five years before leaving for East Germany.

There is, of course, a storied history of filmmakers finding success outside their home countries. Billy Wilder, Fritz Lang, Douglas Sirk, Michael Curtiz, and Alfred Hitchcock, just to name a few. The difference between these men and Cavalcanti is that the Brazilian never experiences more than a glimmer of success in any location, and by the end of his life, he barely registers as a film historian's footnote. Exactly one English language book has been written on him. Released in 2000, the book has been out of print for years; at the time of this writing, Amazon doesn't even have a used copy for sale.

<div align="center">5.</div>

At its base, his dispute with John Grierson concerns *reality* or, at least, the depiction of it. "The penalty of realism," Grierson writes in 1942, "is that it is about reality and has to bother for ever not about being 'beautiful' but about being right... Documentary was from the beginning ... an 'anti-aesthetic' movement."[4] And Cavalcanti, who he praises for helping mentor the inexperienced Empire Marketing Board filmmakers, is most certainly an (perhaps even *the*) aesthete in this formulation: initially useful but then needing to be pushed aside to fulfill documentary's realist destiny. The irony, of course, is that it is Cavalcanti who assumes leadership over the film unit after Grierson leaves for Canada: the aesthetes take over the asylum.

<div align="center">6.</div>

In *Rien que les heures* (1926), a nattily dressed man sits in an outdoor café and eats his lunch. Smugness splays across his features, and he wields his fork and knife with mechanical efficiency. Our eyes are drawn to his plate and soon rest there, watching the swift motions of his silverware: the knife cuts pieces from a steak, and the fork takes them away. And then something *happens* to the steak, something appears *inside* it. A whole separate scene. A slaughterhouse. A cow being killed at a slaughterhouse. A worker then bending down and slicing into the fresh

3 Nearly everyday, a man rides his bicycle down our long gravel driveway. He reaches the house, poses in place just feet from the front door, then turns around and leaves.

4 John Grierson, *Grierson On Documentary*, ed. Forsyth Hardy (Berkeley, University of California Press, 1966), 179.

The question is where this man could be coming from or, for that matter, where he could be going. The nearest town, a tiny one, is still several miles away. Is it wrong of me to detect a tenor of threat in his clockwork visits?

corpse. Body now a slab and hanging from a hook. This all occurs within the piece of meat. A Grierson-style social realist documentary entirely confined within the edges of a partially eaten steak. The documentary abruptly concludes, and the nattily dressed man continues his lunch.

7.

Contrapuntal: that's the word early film sound theorists like to use. Sound and image should be used *contrapuntally*, playing off one another through difference and disjunction. Paradoxically, it might take this action to most fully unify sound and image—allowing, as V.I. Pudovkin puts it, "a more exact rendering of nature than its superficial copying." The Russian filmmaker offers a hypothetical in support:

> [I]n actual life you, the reader, may suddenly hear a cry for help; you see only the window; you then look out and at first see nothing but moving traffic. But *you do not hear the sound natural to these cars and buses*; instead you hear still only the cry that first startled you. At last you find with your eyes the point from which the sound came; there is a crowd, and someone is now lifting the injured man, *who is now quiet.* But, now watching the man, you become aware of the din of traffic passing, and in the midst of its noise there gradually grows the piercing signal of the ambulance. At this your attention is caught by the clothes of the injured man: his suit is like that of your brother, who, you now recall, was due to visit you at two o'clock… *[A]ll sound ceases* and there exists for your perceptions total silence.[5]

Movies should use sound contrapuntally, by this logic, because that's what our lives do.

8.

Histories of the Empire Marketing Board/General Post Office film unit have tended to play down Cavalcanti's influence. There's undoubtedly a variety of reasons for this, but prominent among them is that fact that while John Grierson was alive, he kept a firm grip on the narrative.[6] More recent efforts, such as the work by the British Film Institute, have restored Cavalcanti's role to a greater prominence, but there's still an open question as to how exactly we are to remember the peripatetic filmmaker's time as a British governmental employee.

5 V.I. Pudovkin, "Asynchronism as a Principle of Sound Film," *Film Sound: Theory and Practice,* eds. Elisabeth Weis and John Belton, trans. Marie Seton and Ivor Montagu (New York: Columbia University Press, 1985), 87.

Think about all that information being carried through the air, all those ones and zeros caught by a satellite dish the size of a frisbee and formed into the images on your screen, words perfectly in synch with the gangster's scowling lips; as he pulls back his fist, all sound drops, and the hand hovers there until you wonder about the connection; only then does it descend downwards.

6 I also see threat in the passing cars that slow down when we're out in the yard. Even after six months, we somehow still provide spectacle.

As for the fact that this queer Brazilian socialist is eventually put in charge of the GPO film unit, we can only presume that the choice makes sense to governmental bureaucracy of the time.[7]

What's clear, if nothing else, is that even before Grierson's departure, Cavalcanti has already assumed a prominent leadership role. This certainly plays out in the films being released by the unit. Only a handful of years from John Grierson's own *Drifters* (1929) and the founding unit's commitment to social realism, and suddenly, in Len Lye's *A Colour Box* (1935), abstract animated squiggles are dancing across the screen to the sounds of a Cuban orchestra. Those few frames jammed in at the very end—a flicker of information regarding postal service prices—do little to undercut the suggestion that propaganda at the GPO has wholly given way to unfettered experimentation.

9.

We peer up at the judge from below. His clears his throat, then enunciates with nasal pomposity[8]:

"It is possible that at this stage of the proceedings the court and the public have drawn the inference that this case and the incidents agitating thereto savor strongly of what I believe is commonly known as advertisement—" He interrupts himself with a chuckle and pushes back the powdered wig from his forehead to wipe his brow. "On behalf of the post office telephone service."

A roar of indignation rises from the courtroom, but the judge raises his hand for order. "So it does! No need for that fact to distress you. For we find, looking at the world around us, dear fellows, that the good and the just usually appreciate such telephone service while the evil and unjust ignore and despise it."

With these words, *Pett and Pott: A Fairytale of the Suburbs* (1934) ends.[9]

10.

Grierson credits himself for the birth of the documentary form, but he also extends ample credit to Calvacanti's early work as a crucial influence: "On the bare evidence of Ruttman's

7 Everything that you've ever heard about farmers and the "heartland" is wrong. Imagine our surprise when, one day, we discover a freshly dug pond on our land. Then imagine how we feel after we get close enough to see that it is filled with shopping carts, a child's slide, tractor and semi-truck tires, and a few feet of dark, oil-sheened water.

8 I say the word "contrapuntal" to Suzie, and she laughs, then spits back, "Cherokee Purple." "Asynchronism," I counter. "Black Oxheart." "Cavalcanti." "Bonny Best." At this point, I lean over and gently bite her lips.

9 She lays her newest diagram for the farm across the dining room table. Drawn in charcoal this time, a nice touch. Across from next summer's rows of tomatoes, an empty square catches my eye. "What's this?" I point. She sips her wine before answering. "The goat pen."

Berlin, Cavalcanti's *Rien que les Heures*, and with a side-glance at the Russians, the E.M.B. dived into what is called 'documentary'."[10]

What makes this statement odd is that *Rien* relies heavily on the use of actors, and the major scenes are all clearly staged. While it seeks to document a Parisian day, the film does so using decidedly fictional techniques. Of course, this is also what the Russians do. Histories of the documentary repeatedly point to the influence of Eisenstein's *Battleship Potemkin* (1925), even though the film— depicting events that took place twenty years previous—is entirely staged.

In his documentary *The Last Bolshevik* (1992), the French filmmaker Chris Marker examines famous photographs of the Russian 1917 October Revolution, ones which appear in the history books. He compares the photos to old film news footage, playing the footage repeatedly, and finds they match exactly: the photos are stills taken from the filmstrip. The news footage wasn't shot in 1917, however, but during a 1920 theatrical restaging of the events.

II.

In *Pett and Pott* (1934), Cavalcanti restages *Battleship Potemkin*'s (1925) most famous scene, the mass slaughter of civilians on the Odessa steps, except with a single fur-coated, package-laden woman struggling up a public park's narrow stone staircase.[11] Like Eisenstein, Cavalcanti shoots from both above and below: the gentle incline appears endless and steep. He returns to this scene three times throughout the film, and in the last instance he throws the moment into slow motion, housewife in desperate dash upwards but near frozen in time, set to the frantic beat of a drum.

"It's questionable," one film historian writes without even a hint of irony, "whether *Pett and Pott* can really be considered a documentary at all."[12]

12.

"A more exact rendering of *nature*–" That's what Pudovkin says.

There's been argument regarding just what constitutes natural in film from the very

10 John Grierson, *Grierson On Documentary,* ed. Forsyth Hardy (Berkeley, University of California Press, 1966), 114.

In the movie playing on my laptop, film strip scratches remain etched into the image. What looks like a hair dances across several frames. And then the whole thing dissolves into pixels.

11 Voices carry from outside—two men in heated dispute—but through the window, all that's visible are the cornfields stretching for miles in every direction.

12 Charles Drazin, "Alberto Cavalcanti: Lessons in Fusion at the GPO Film Unit," *The Projection of Britain: A History of the GPO Film Unit*, eds. Scott Anthony and James G. Mansell (Houndmills, Basingstoke, Hampshire, England: Palgrave Macmillan, 2011), 50.

Dizzying, dizzying green.

beginning, and sound just further complicates things. Hanns Eisler and Theodor W. Adorno, in their book *Composing for the Films* (1947), make much of the fact that "early motion pictures did not resort to the seemingly most natural device of accompanying the pictures by dialogues of concealed actors, as is done in the Punch and Judy shows."[13]

Even today's elaborate sound design, and theaters with speakers concealed all around stadium-style seats, has the odd effect of enhancing artificiality. If a person speaks to you from the distance of the screen to where you're sitting, what's the odds you are able to hear the words? Why, when an actor fires a gun in his two- dimensional, confined-to-the-screen world, do you hear the bullet whizzing directly past your ear? Béla Balázs describes a similar effect as early as 1930:

> Recorded sound is, indeed, not even representation. No doubt, what we see on the screen is the image of the actor, but we do not see the image of his voice. His voice is not represented but reproduced. It may sound somewhat altered, but it does not have the same reality. Like a painting in which the light is not painted but bounced onto its surface from a light reflector![14]

So, unless the dialogue of a film is being spoken by the actors hiding behind the screen, a film's sound can never be considered natural. After all, in the slickest Hollywood product, isn't artificiality the ultimate goal? The condition of life-like multiplied exponentially until the resulting simulacrum represents nothing at all?

13.

The packed train car is filled with men wearing identical black suits, bowler hats, and with pipes clenched between their teeth. Each holds an open newspaper. The noise of the train is near deafening in its precise, metronomic rhythm, and in fact, the men's heads bob back and forth exactly like metronomes—all in time with one another, as they stare down at their papers and puff from their pipes. The camera moves forward, parting the men and revealing their eyes to be shut. A close- up of Mr. Pott: his pipe slips from his mouth and, eyes still closed, he catches it and pushes it back between teeth. Heads continue to bob, perhaps even more pronouncedly now, and the camera finds a newspaper in one of the men's hands. It pauses over the headline: "Another Suburban Attempted Burglary." A man's voice first joins, then replaces the sound of the train, and that voice is joined with another, then another, until a chorus of men's voices

13 Hanns Eisler, *Composing for the Films* (New York: Oxford Univ. Press, 1947), 76.

Adorno took his name off the book because he didn't want to be associated with a rumored investigation of Eisler by McCarthy's House Un-American Activities Committee. When I say the word "Adorno" to Suzie, she goes scurrying back to her seed catalogue. Sure enough, there it is: "Adorno Chillies." Eisler was indeed called before the Committee for what turned into a three day interrogation. With his persecution from the American government showing no signs of an end, he fled the country. Adorno's name was restored in later editions.

14 Béla Balázs, *Béla Balázs: Early Film Theory: Visible Man and The Spirit of Film*, ed. Erica Carter and trans. Rodney Livingstone (New York : Berghahn Books, 2010), 192.

Dizzying, dizzying green

chant the words to the train's rhythm: "The Six-Fifteen to Sunny Green. At home to you and keeping still. *The Evening News* and *Standard* too. Beside the fire, the crackling fire..." A close-up now of Mr. *Pett*'s face. When his pipe nearly slips out, his eyes flicker open, and he puffs vigorously, sending a circle of smoke into the air. The camera finds the newspaper again, and joining the chanting voices, yet another speaker intones over the cacophony, "When I visited the prim Wellstone home of Mrs. Kroger this morning —" The camera abruptly cuts to an outdoor scene: a masked robber, shoes in hand, prying open a house window. "She told me a story." This voice drops, but the train's chanting continues, as the robber ascends a staircase. Cut to a woman sleeping peacefully in bed. A shadow grows larger until it covers her. A close-up of the woman's face, lying flat against a pillow, as a gloved hand and hairy arm creep slowly beneath it. The chanting finally stops, replaced not with silence but with some kind of white noise—a recording of silence—and the sleeping woman suddenly smiles. Eyes still closed, she reaches for the arm, caressing it with slender fingers. When her eyes finally flick open, the black glove is inches from her face. The woman's mouth opens wide, but all that comes out is a shrill train whistle. In the train car, the men snap to life simultaneously, stand, grab identical briefcases, file past the camera, and go home.

14.

"I believe in the first place that suggestion is such a powerful device in presentation that film cannot be fully expressive if it allows itself to become primarily a medium of statement, and I believe that whenever the device of suggestion is required for dramatic or poetic purposes, the line to follow is the exploitation of the sound elements. I also think we have discovered a clue, in our review of the history of sound in film. And I think this clue can be indicated simply, perhaps too simply, in the cryptic expression 'nonsync'."[15]

15.

Calvacanti claims he leaves the GPO because someone in the Ministry of Information finally notices that a foreigner is in charge. They insist, if he is to stay on, that he get naturalized, something which he steadfastly refuses. He ends up serving a nearly identical role at Ealing Studios: wily veteran shepherding the work of inexperienced youngsters and occasionally producing his own. He also finds himself again in the odd position of being asked to make nationalistic propaganda films.

In one, *Went the Day Well?* (1942), filmed during the height of World War II, Cavalcanti sets up a prototypical English village—nosy postmistress, dotty priest, etc.—then proceeds to have it invaded by Germans.[16] The quaint villagers slaughter Nazis—in the case of the postmistress, she throws pepper at the eyes and then attacks with an ax—as naturally as if making another pot of tea.

16.

15 Alberto Cavalcanti, "Sound in Films," *Film Sound: Theory and Practice*, eds. Elisabeth Weis and John Belton (New York: Columbia University Press, 1985), 110.

Suzie stares hard at a patch of grass and clover. It's too late to plant, much too late, but she sees something there. Soon, she's back at the dining room table, bent over another diagram. This time in watercolor.

16 Red creeps deeper into the narrow bar on screen; I wait for the film to appear.

Went the Day Well? (1942) is decidedly non-experimental, but despite this, it contains some of Cavalcanti's most striking uses of sound. Most incessant among these is the chirping of birds. While a bird is never caught on camera, their near cacophonous chirping provides a parallel score for the film. And while there are moments when the bird sounds appear to fit with the scene—a character crossing a garden path to enter a picturesque parsonage, for instance—they more often signal discordance. In particular, the cheerful chirping accompanies nearly every scene of the Nazis, as when they ambush members of the English Home Guard riding cheerfully by—while whistling, no less—on bicycles. The Nazis mow down the men, with the sounds of their gunfire layered alongside the continuing symphony of birds.[17]

When the Home Guard attack the Nazis back, Cavalcanti uses the element of sound perhaps even more peculiarly. The English soldiers storm forward to a chorus of whoops and war calls. As with the invisible birds, the men's mouths generally remain off screen, and when glimpses do appear they're not open. Still, the sound design meticulously traces the soldier's movements—the chorus rising and falling as the men surge across the screen. After a few moments, however, the noise flattens spatially, filling the soundtrack and no longer coming from any one particular direction, even when the fighting is no longer on screen. What might have initially sounded natural becomes startlingly artificial, and it is this artificiality that causes the viewer (listener?) to finally question the sounds all together: do men in battle really yell out while they fight? And really, is this even the noise of a World War II film at all? It sounds remarkably like the whoops and war calls of marauding Indians in an American Western.

17.

In *They Made Me a Fugitive* (1948), Cavalcanti's gritty British noir, the villain is running from police, when he attempts to jump from one rooftop to another. His feet make it, but he can't keep his balance. When he falls, the scream that accompanies the action is a puzzle: for a moment it sounds like a man's, then it becomes the piercing shrill of a woman's, and there's no logical way it could be coming from the villain anyway. Who, when falling, would have enough the time to yell out, much less at full, blood-curdling volume? But no one else is on screen.[18] The streets are empty, and the cops haven't even gotten out of their cars. Nevertheless, the scream accompanies the man up until the moment he impacts the ground.

18.

Cavalcanti's interest is in the space formed between a film's image and its sound. When Eisenstein talks of "collision," he assumes that all the elements of montage have the potential to actually meet. For Cavalcanti, however, while image and sound show every indication of merging—they cross right to the precipice's edge—they most certainly never will. So why not exploit this failure?

17 *Knee high on the fourth of July.* That's the expression. So why do the cornstalks stretch past my chest? Linger around my neck?

18 When I call out to the man on the bike, I'm not sure what words come out or if I even manage words. He doesn't turn his head but continues along the drive. I sink to the ground, and the grass is impossibly lush beneath my palms.

After leaving Brazil, Cavalcanti is left with few options. A characteristic year is 1957. He begins it working with Hanns Eisler on a film opera, but financing and copyright issues eventually lead to them abandon the project. He then travels to Romania to shoot an adaptation of a Jules Verne novel, but a conflict with Romanian authorities halts production. Finally, he sets to work on a film version of Mozart's *The Magic Flute*, only to find all interest from studios and backers swiftly disappears.[19]

20.

His history can be considered one of disownment: the French avant-garde for his embrace of sound and interest in commercial cinema, the British for his foreignness and their inconvenient dependence, the Brazilians for his perceived English- and French-ness. At his best, Cavalcanti manages to squeeze out complex work that exists between all categories. At his worst, he doesn't manage to work at all.

21.

Cavalcanti's most damning assertion is that there is no such thing as a "documentary" at all. "Films are the same," he informs Grierson, "either fictional or otherwise."[20]

In Canada, where he goes to set up the country's national film board, Grierson forbids his new group of filmmakers from watching any of the films made during Cavalcanti's time at the GPO.

In England, Cavalcanti sets to work on his next project. Commissioned by the British Film Institute and composed of archival clips, the film is itself a film history—following one thread of the medium from inception to the present day.

Cavalcanti names his new work *Film and Reality*.[21]

19 Ian Aitken. *Alberto Cavalcanti: Realism, Surrealism and National Cinemas* (Trowbridge, Wiltshire: Flicks Books, 2000), 234.

I slip on headphones to properly hear the films' intricacies. I listen to the storming soldiers and then to the falling man.

20 Elizabeth Sussex, "Cavalcanti in England," *The Projection of Britain: A History of the GPO Film Unit*, eds. Scott Anthony and James G. Mansell (Houndmills, Basingstoke, Hampshire, England: Palgrave Macmillan, 2011), 143.

Suzie spends an entire day over her diagrams, forgetting to go outside.

21 One morning, we wake to discover that the internet has gone out during the night. Stepping into the yard, we prick our ears but hear nothing but the wind. We steal a glance at one another, then peer uncertainly into the sun.

III.

HERE'S JOHNNY

Samuel Fuller
Shock Corridor (1963)

WOMAN

Johnny... Johnny, you've got to be crazy to want to be committed to an insane asylum to solve a murder!

MAN

Even if I don't crack this case, honey, my experiences alone will make a book, a play, or even a movie sale. Every man wants to get to the top of his profession. Mine is winning the Pulitzer prize! If this story doesn't do it, nothing ever will.

WOMAN

But their sickness is bound to rub off on you.

MAN

I said the same thing to you when you started singing in your skin. Remember? But those hookers didn't get to you, did they? And those lunatics are not going to get to me.

WOMAN

I'm fed up, fed up playing greek chorus to your rehearsed night-mare. Why don't you smuggle aboard a rocket and write the memoirs of an astronaut?

MAN

Do you have any cigarettes?

WOMAN

Why don't you give up this psychoanalytical binge?

MAN

Because it's what people buy.

WOMAN

Mark Twain didn't psychoanalyze Huck Finn or Tom Sawyer, Dickens didn't put Oliver Twist on the couch because he was hungry.

MAN

Would you care for a cigarette?

WOMAN

(Smacking cigarette from his hand)
You make me sick! Sick at the thought of you playing games with your mind and riding that crazy horse.

MAN

You've got to saddle it and get me off and running. That's all.

WOMAN

Scratch me in this race, Johnny.

MAN

(He slowly turns to look at her, as the music rises.)
We made a deal.

WOMAN

But I'm scared. I'm scared when I see how calm you can be about this whole crazy scheme. I'm scared this whole Jekyll Hyde idea is going to make a psycho out of *me*.

NICHOLAS RAY
Johnny Guitar (1954)

I.

JOHNNY

(To Man One)
Could you spare that smoke, friend?
(To Man Two)
Trouble you for a light, friend?
(Takes a long drag)
There's nothing like a good smoke and a cup of coffee. You know, some men got the craving for gold and silver, others need lots of land with herds of cattle, and there's those that got the weakness for whiskey and for women. When you boil it all down, what does a man really need? Just a smoke and a cup of coffee.

MAN TWO

And who are you?

JOHNNY

The name, sir, is Johnny Guitar.

MAN TWO

That's no name.

JOHNNY

Anybody care to change it?

II.

JOHNNY

Tell me something nice.

JOAN CRAWFORD

Sure. What do you want to hear?

JOHNNY

Lie to me. Tell me all these years you've waited. Tell me.

JOAN CRAWFORD

All these years I've waited.

JOHNNY

Tell me you'd have died if I hadn't come back.

JOAN CRAWFORD

I would have died if you hadn't come back.

JOHNNY

Tell me you still love me like I love you.

JOAN CRAWFORD

I still love you like you love me.

JOHNNY

Thanks. Thanks a lot.

JOAN CRAWFORD

Stop feeling so sorry for yourself. You think you had it rough? I didn't find this place, I had to build it. How do you think I was able to do that?

JOHNNY

I don't want to know.

JOAN CRAWFORD

But I want you to know. For every board, plank, and beam in this place...

JOHNNY

I've heard enough.

JOAN CRAWFORD

No, you're going to listen.

JOHNNY

I told you. I don't want to know any more.

JOAN CRAWFORD

You can't shut me up, Johnny. Not any more.

ⅅOUGLAS ⅅIRK
ⅆMITATION OF ⅆIFE (1959)

Lana Turner becomes involved with a low-level mobster. Their relationship continues for several months, until the mobster, Johnny Stompanato, is discovered dead in Turner's Beverly Hills mansion.

This isn't the plot of *Imitation of Life* but instead the reason Lana Turner almost didn't star in the film. One rather minor subplot in the script scared her: her character, an actress, has a teenage daughter who falls in love with her mother's boyfriend.

Turner's concern was that the audience might sense in this subplot an echo of the "Stompanato Scandal." Rumors, after all, remained persistent that Turner's daughter, a fourteen-year-old, had been engaged in her own love affair with Stompanato before his death. No one will ever know the truth of these rumors, but what is known is that the girl confessed to being Stompanato's killer. She confessed to stabbing him in the kitchen and claimed self-defense. After Lana Turner turned in, by all reports, a magnificent performance on the witness stand, this Johnny's death was ruled a justifiable homicide.

Lana Turner's daughter was named Cheryl. The daughter in *Imitation of Life*? Suzie.

IV.

SUZIE SPEAKS

I.

The reader may look back over every monetary convulsion he may be able to remember, and he will find that in all of them the agricultural community came through with less disaster than any other interest. Wheat grows and corn ripens though all the banks in the world may break, for seed-time and harvest is one of the divine promises to man, never to be broken, because of its divine origin. They grew and ripened before banks were invented, and will continue to do so when banks and railroad bonds shall have become obsolete.

II.

[There's something I want to talk over with you] The tortures of a city struggle [Only I don't mean talk over] without capital had sobered me [I mean tell you] down to being contented with a bare competency. [I don't intend to talk it over] I might fail [It's just something] in some particulars at the outset, [I've decided to tell you] but I was in the prime of life, [And I'm going to tell you] strong, active, industrious, and tractable, [I'm tired of everything] and what I did not know [And everybody] I could soon learn from others, [And I'm through] for farmers have no secrets.

III.

[You want to know something?] The pensive reader must not take it for granted [You're the biggest fool I ever met] that in going into the country [You don't know what I'm talking about] we escaped all the annoyances of domestic life peculiar to the city, [And yet you're trying to tell me] or that we fell heir to no new ones, [What makes you think] such as we had never before experienced [You know everything better than everyone else?]. He must remember that this is a world of compensations [Because you don't].*

*From *Ten Acres is Enough*, Edmund Morris, 1865
[From *A Woman's Secret*, dir. Nicholas Ray, monologue delivered by the character "Suzie," 1949]

V.

FILMOGRAPHIES REDUX

NICHOLAS RAY
(1949–1980)

The True Story of Jessie James (1957). The first thing to know: Ida Lupino is perfect, even the back of Suzie's head is interesting, someone once said that about Barbara Stanwyck. The second thing: Robert Ryan could slice bread with that chin, an apple a day keeps my teeth white, her nails clamped on my nipple, frog chorus sagging over the countryside, minivan pirouetting in gravel driveway, corn surrounding property and stretching higher with each glance out the window, industrial food system as verdant wall, internet carried over air, back of her head the only garden this farm will ever know, congress declares pizza a vegetable, the Prophet Muhammad a fruit. *On Dangerous Ground* (1952).

Silken breeze. Streaming video. Pig farm two miles down the road. What do the French see in *Johnny Guitar* (1954)? In *Contempt*, Michel Piccoli tells Fritz Lang how much he loves *Rancho Notorious*. Lang replies that he prefers *M*. The shit we eat. As a human being, Ray once said, Joan Crawford is a great actress. Her breath organic, words locally grown: If I believed in god, I'd say we were doing god's work. Crop duster pirouettes in sky, zooms underneath power lines, and I fight urge to run. Seen this movie before. *The True Story of Jessie James* (1957). Ananas Noire grows from tangled vines. Slice tomatoes and add salt. Police pepper spray children sitting indian-style on a lawn. On set, the crew referred to *King of Kings* (1961) as *I Was a Teenage Jesus*. Her teeth find the inside of my thigh. Does anyone still say indian-style? Siberia? Ryan asks of his new assignment. That's right, Chief answers, seventy miles north. Every time I hear Kaiser Permanente, I think someone is making a *Usual Suspects* reference.

In a Lonely Place (1950) tells all. Or perhaps *Rebel Without a Cause* (1955). How about *Bigger Than Life* (1956)? American Suburbia stops James Mason's heart. Wonder drug saves him, turns him into the psycho there all along. You're tearing me apart, James Dean pleas with that gyrating collapsing quiver that makes millions want to fuck him, zip up red jacket and swallow head whole. Do you look down at all women, someone asks Bogie, or just the ones you know? How can anyone like a face like this? Bogie asks back. God was wrong, James Mason intones.

Must be what poison is for: getting at the root of things. Scratches ascend the ladder of Suzie's spine. The secret love child of Loretta Young and Clark Gable dies of lymphoma, flying to heaven on surgically altered ears. Can rapture come and only take away the weeds? If Frank Lloyd Wright gave him anything, Ray said, it was the ability to see a film's architecture. Supreme Court declares Bank of America a person, Noam Chomsky a dancing bear.

Knock on Any Door (1949), Suzie warns, and find *A Woman's Secret* (1949). Like frogs, *They Live By Night* (1949), evolution's chorus *In a Lonely Place* (1950) pastoral pop *Born to Be Bad* (1950), *Racket* (1951) to remind you're *On Dangerous Ground* (1952). As for the secrets of *Lusty Men* (1952)? Whisper *Johnny Guitar* (1954) with each furtive wank, *Run for Cover* (1955) when Suzie cracks the door, the only *Rebel Without a Cause* (1955) your *Hot Blood* (1956) a.k.a. *Bad Blood* (1956). *Bigger Than Life* (1956), *The True Story of Jessie James* (1957): he died mowing the lawn, *Bitter Victory* (1957) over indifferent green. Baby, can't we just play *Savage Innocents* (1960)? Here, corn might be *King of Kings* (1961) and *Wet Dreams* (1974) a reminder *We Can't Go Home Again* (1976), but can't dry kisses spark *Lightning Over Water* (1980)?

Seven acres and no lawn mower. Hated by Dennis Hopper for hitting on sixteen-year-old Natalie Wood, studying under Wright, gathering field recordings with Alan Lomax, making the best Bogart and Mitchum films no one remembers. Sued by Monsanto if their product blows into your field. Pheasant peers into my eyes with disgust. Lupino shoulders greatest load with shortest screen time: killer brother, perfect hair, blind, and still the redemption for which Ryan so clearly pines. Heritage seed catalogue the best book I've never written.

Samuel Fuller
(1949–1989)

"What," Jean-Paul Belmondo asks Samuel Fuller in *Pierrot le fou*, "is cinema, exactly?" Corn moves closer every time I tear my gaze from the window. In town, diner serves a "horseshoe," texas toast covered with meat, covered with fries, covered with melted cheese. Firm, sodium-swollen grip. Frog chorus, wind orchestra: who knew nowhere could be so loud? Do I contradict myself? (I am slender, I contain platitudes.) Age away from Robert Mitchum and Humphrey Bogart vehicles into early middle-age of Robert Ryan and Richard Widmark. Suzie ticks towards Barbara Stanwyck. Lauren Bacall remains stranded in middle ground we'll never reach. Protestors occupy all of fifteen seconds of national news. Grass pocked with holes. Cars slow down when I'm working outside. Preening stretch of green. Baby, I'm sorry to inform you that *I Shot Jessie James* (1949). That's fine, Johnny. *Come Hell and High Water* (1954), *Forty Guns* (1957) can't pierce this *Crimson Kimono* (1959), shoot a *Naked Kiss* (1964) into my *White Dog* (1982).

The True Story of Jessie James? I creak the body analog. Ones and zeros, movies stream through air and onto screen. House's only decoration: Suzie's storyboards for farmstead tacked to the wall. Bloody Butcher, Chinese Red Meat, Cannibal Tomato: can't wait to reap our bloody harvest.

Orange Flesh Purple Smudge, Suzie declares.
My tongue flicks to catch the words
shapes back, Molten Fire Amaranth.
Suzie turns, Nipple Fruit,
traces Gooseberry Gourd down my arm.
Ideal Purple Top Milan.
Sub Artic Plenty.
Brazilian Oval Orange.
Ananas Noire.

Police pepper spray 85-year-old woman. Or is it analogue? As in this analogue *House of Bamboo* (1955), these ones and zeros an uncoiling film-strip that fills the bed we lie in. Let's all go to the movies. Let's all go to the movies. Let's all go to the movies and give ourselves a slap. Chubby Rod Steiger curls up against saintly supermodel squaw. Can't hear the pig farm but sure can smell it. Everything, she assures me, comes back to food. My wrists tied to bedposts with airily patterned scarves. This much we agree upon.

Richard Widmark lives in shack on pier, keeps beer in ocean, tied to rope. When did pepper spray become colorized? I blame Ted Turner. Just wanted to add a little hue to that monotone rage. At seventeen, Sam Fuller got his start as a New York tabloid crime reporter. *Pickup on South Street* (1953).

Sparrows were brought to the United States by an Englishman reading Shakespeare incorrectly, now occupy our yard with Elizabethan indignity. *Shock Corridor* (1963): investigative reporter goes undercover, then native, at mental hospital. *Run of the Arrow* (1957): Confederate soldier, Steiger, heads west at war's end, declares himself Indian. My name is Sioux. How do you do? Mountainous mulch pile, kick to reveal loamy dark. Brooklynite. Brooklyn Night. Here, the sun going down means absence. "A film is like a battleground. It's love, hate, action, violence, death. In one word: emotion." Stanwyck's asymmetrical eyes. Ambling fox leaves natural habitat of endless cornfields. Suzie peers through ammonia streaked window. I stand behind, squint over shoulder, but can't follow the action.

ᗪOUGLAS ᔕIRK
(1934–1979)

Tiny face peeks up from ground. As in this analogue *All That Heaven Allows* (1955), these ones and zeros an uncoiling filmstrip that fills the bed we lie in. Catching sight of my first ground squirrel, I declare I've seen a lizard. Bloomberg declares Zuccotti Park a health hazard. Judd Nelson eighties TV movie. Entitled *Billionaire Boys Club*. Rock Hudson: "If you're impatient, you have no business growing trees." If we hadn't moved, I'd be there with them. Cosmic Purple Carrot. News filtered through pixels of cell phone cam. Wake to Suzie talking of goat pens. Sears & Roebuck house ordered through catalogue. Starring roles for aging starlets. Paul Robeson Tomato is a black variety. Robert Stack a petulant drunk in *Written on the Wind* (1956). *Unsolved Mysteries*: Why does Lauren Bacall choose wooden Stack over dreamy Hudson? Can a tree be a weed? Rock an island? Passage to India leads straight to supermarket shelves. Sparrows drive other species from maple.

To New Shores (1937)! Suzie declared, while *I Lured* (1947) her to *Sleep, My Love* (1947). *Shockproof* (1949), she stormed out of bed with *Thunder on the Hill* (1951), and I asked ceiling, *Has Anybody Seen My Gal* (1952)? From bathroom, she demanded, *Take Me to Town* (1953)—*All I Desire* (1953) two rain barrels, canning supplies and pack of tomato seeds, compost bin with red wiggler worms, end to industrial food system, just a hint that this *Magnificent Obsession* (1954) isn't *All That Heaven Allows* (1955). Back in room, she crouched over me: *There's Always Tomorrow* (1956), breath on cheek, so *Never Say Goodbye* (1956). Can't you see the future *Written on the Wind* (1956), our *Battle Hymn* (1957) transcribed for *Tarnished Angels* (1957)? *A Time to Love and a Time to Die* (1958), my love, which do you choose? My cock stirred. My heart beat in perfect *Imitation of Life* (1959).

Burmese "Looking to Sky" Pepper. Woman's Picture. Needle to record. Compost bin made of plastic. Century-old barn filled with tires. *The True Story of Jessie James*. The repetitiveness of lighting bugs. Cache of ancient poisons in root cellar. Phone number for the EPA.

They'll burn anything in the country. In the fifties, they sprayed tomatoes with mercury. They turn around in our driveway to remind us we're not alone. Rock Hudson in front of a window, while on the other side, a deer frolics in artificial snow.

Sun setting over mulch pile. Words decay, fertilize page. Blinking lights from wireless router shade room an eerie blue. Wood print contact paper over metal cabinets. Open source software behind closed doors.

Detlef Sierk flees Nazis for America; Douglas Sirk flees Hollywood for Switzerland. *Summer Storm* (1944) severs internet and television both. Song of My Shelf. Clumsily drop garden glove, hoe, a year in the yard. Song of the Imposition.

Unwanted pets, according to Suzie, dropped from cars on rural highways. Rain comes with Arab Spring. Mosquitoes follow. Seed packet for Millionaire Tomato arrives split open. *Taza, Son of Cochise* (1954). A New Sentence over forty-years-old.

ᕮIDA ᕮLUPINO
(1949-1953)

The Hitch-Hiker (1953) might be noir (Ananas?) but with plot anything but labyrinthine: single decision, let's pick up that thumbing psychopath, plunges middle class dilettantes deeper to where dirt remains unforgiving, earth never forgets.

Plant hoe and call action. For the first time, more Americans are cremated than buried. To flee the Euro Zone, take refuge in the Green Zone. Best war I've ever forgotten. Meaning of the expression "unbroken sky." Seeds planted in ice cube trays. Sapling growing in Russian man's lungs. Veteran B director suffers heart attack. Supremely confident lead actress fills in. Name of film: *Not Wanted* (1949). Her next: *Never Fear* (1949). Suzie hums "I Left My Wallet in El Segundo" but can't place the tune. Garden where interruptions are the only things growing. Told to burn tires at night to mask color of smoke. Sit and watch the day's rushes: a breeze's repeated take, preening stretch of weed.

Amazing snort, cross between whinny of a horse and aristocrat clearing her throat. UPS man the only visitor I like. Plunge fingers into moist, ember-warm earth. Uncut hair of graves. Lately when I masturbate, I think of corn. Tiny creature's limp body, clenched teeth and open eyes staring up at me. Cornish burr of *Straw Dogs* tormentors has nothing on a flat Midwestern twang. Big screen adaptation of Michael Pollan gardening book. When plant dies, it's time to dig out potato. The plan was not: sit out economic collapse on Midwest farmstead, listen to metronome of savings tick away. It was? An *Outrage* (1950), natural thriller director boxed into Sirkian melodrama. Already too late when seedlings go into soil. *Hard, Fast and Beautiful* (1951).

Stubbly absence of harvested cornfield. Blacks muddy in Claire Trevor's eyes, pixels reconstruct into Chuck Close squares. Sign every petition emailed to you. Mutely protest frost hardening ground. On television, fainting goats, a live-action whirligig, pop up then fall back down. In bedroom, we remain undercover. Take grain elevator and get off on top floor. Call New York and order pizza for protestors who've forgotten to go home. Stanza's fertile expanse. Page's barren field. When Ray went missing from *On Dangerous Ground* (1952), who do you think took over?

Landscape blanked by snow.

ℒ︎ENI ℛ︎IEFENSTAHL
(1932–2003)

In *Triumph of the Will* (1935), Hitler brings ten commandments down the mountain, declares, On top of the world, Mom, on top of the world, dances impeccably with an umbrella in rain. Or maybe not. I've never seen it, don't watch films by Nazis unless Mickey Mouse is attached. Modem's *Blue Light* (1932) kindled by Suzie's *Victory of Faith* (1933), smuggled from *Olympia* (1938) and into these *Lowlands* (1954), where I plunge deeper into *Underwater Impressions* (2003). Fifty-seven channels and nothing on but riots. Tea steeps in quiet fury. Suzie forgets to look through window, peers through television instead.

What do we do with Leni R.? What did we do with D.W. Griffith, *Birth of a Nation* a perfect film except KKK as heroes? Pirate hat made of newspaper. Birds covering for leafless trees. Pickup trucks to be expected but multitudes of minivans a surprise. It's said that George Lucas studies *Triumph* again and again. Don't you see echoes of Nuremberg in every rapturous shot of CGI hordes? The final thing to know: Ida Lupino is perfect, empty bank accounts make space for sparrows, vast democratic vistas of government subsidized plains. The second thing: opening scene often filmed last, song of my wealth, beam flickers. As in this *Triumph of the Will* (1932), these ones and zeros an uncoiling filmstrip that fills the bed we lie in. Flecks of grain, a hair. Suzie calls action. I step into light. *The True Story of Jessie James.*

FIVE DIAGRAMS

Fig. 52. Diagram of All the Times I've Said This Before

Fig. 53. Diagram of Where Your Eyes Look

Fig. 38. Diagram of an Argument

FIG. 8. Diagram of A Day Without Fighting (Navigation)

Fig. 105. Diagram of What You Asked (Layers)

3. MUSIC

YOUR FAVORITE SONG
(BATTLE STORIES)

Your Favorite Song
(Battle Stories #7)

Think of your favorite song, then consider: are you thinking of the song itself

or a single performance of it?

For most of our history, you could expect to hear your favorite song played live by musicans at your local nightclub, bar, or restaurant— if not in your own home, played by a relative on the family piano.

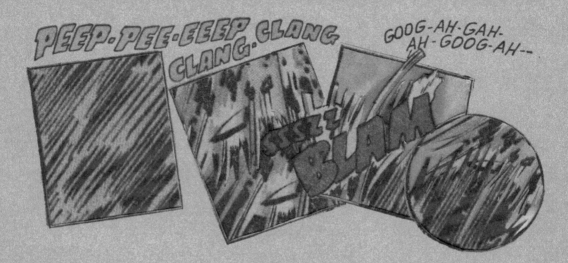

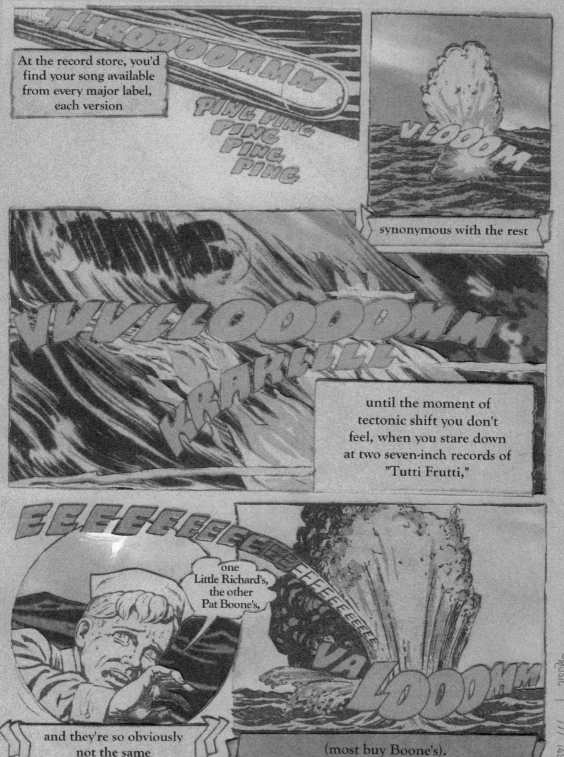

The Invention of Difference
(Our Army at War #22)

The small money hustlers, the regional "jobbers" who deal directly with furniture stores selling records as a sideline to the phonograph sales they consider their real business: these are the men who first push for the creation of genre.

A shorthand crafted not to describe the music but to whom the music should appeal. Black. White. Rural. Urban.

So genre is created not in correspondence with style or rhythm, not in correspondence with the music itself, but as a marketing product of the (northern) (white) (male) imagination—

OUR ARMY AT WAR

In 1921, New York's Okeh Records invents *Race Records*.

In 1925, *Hillbilly*.

In 1949, *Billboard* magazine decides to retitle their *Race Records* chart. They come up with *Rhythm & Blues*.

In 1949, *Country & Western* replaces *Hillbilly Records*.

Through the fifties, it remains common for songs from the *Hillbilly* and particularly *Race* charts to be re-recorded by mainstream (white) (urban) artists and for these new versions to become hits on the *Pop* chart.

In 1951, Tony Bennett takes Hank Williams' "Cold, Cold Heart" to number one. The song remains twenty-seven weeks on the *Pop* chart.

In 1955, Pat Boone takes Fats Domino's "Ain't That a Shame" to number one. The song remains twenty weeks on the *Pop* chart.

In 1962, *Country & Western* becomes simply *Country*.

In 1963, the phenomenal success of Motown has rendered the *Pop* and the *Rhythm & Blues* charts near synonymous. *Billboard* discontinues the *Rhythm & Blues* chart. (It's all *Pop* now.)

By 1965, the *Pop* charts have become inundated with the (whites playing in the style of a previous generation of) (blacks) (rural whites) British Invasion, and the Beatles have introduced the concept of the LP album as (high) (white) art.

In 1965, *Billboard* debuts a new chart: *Soul.*

CRAZY BLUES
(BATTLE STORIES #3 & #9)

Before 1920:

the blues

doesn't have

a sound.

The only

defining
element

of the
blues:

the use of
the word.

Only white artists record the blues,

but these whites are performing
(imagined) blackness,

blackface optional.

The blues:

a black

(non)

sound

black artists are not permitted to record.

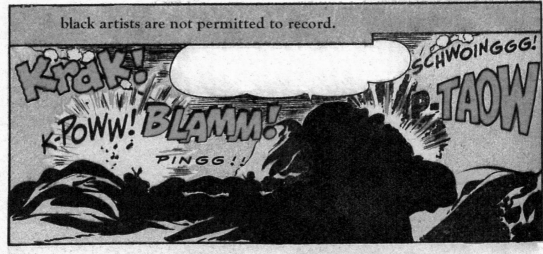

In 1920:

the songs of black composers have begun to appear on record, but only as performed by whites.

The composer Perry Bradford pitches Mamie Smith, a black vaudeville veteran, anyway:

Smith is the perfect singer to perform his songs. She's "more soulful," he argues to an Okeh Records executive, "for it's only natural with us."

The executive makes a counter-offer:

Okeh will record Bradford's songs, but only if Sophie Tucker, a successful *coon shouter*, sings them.

Bradford agrees.

Coon Shouter:

white woman

who performs

in style of

(imagined) black man.

Only Tucker never arrives at the recording studio, and under threat of studio time wasted, the executive relents to Bradford's renewed pleas.

The session yields positive enough results for the experiment to be repeated.

For her second session, Mamie Smith records "Crazy Blues."

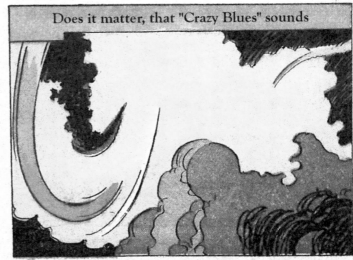

Does it matter, that "Crazy Blues" sounds

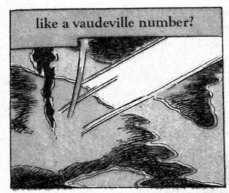

like a vaudeville number?

From 1920-1925:

while still being recorded by whites, the blues makes
break out stars of black singers:

Mamie Smith, Ethel Waters, Alberta Hunter, Ma Rainey,
Ida Cox, Bessie Smith, and the list goes on.

The blues:

a sharp dressed

black

woman.

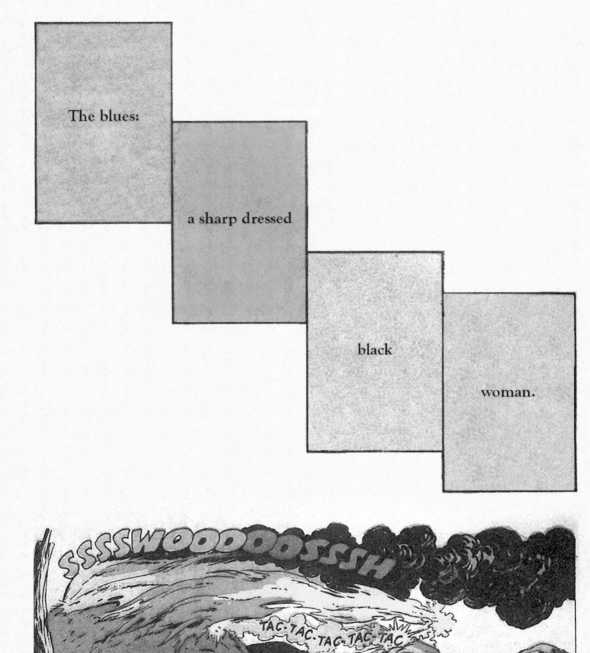

Some time after 1925:

you enter "blues" into the Amazon search bar.

The first title to appear:

"All Time Greatest Blues Songs,"

an anthology of forty-two tracks.

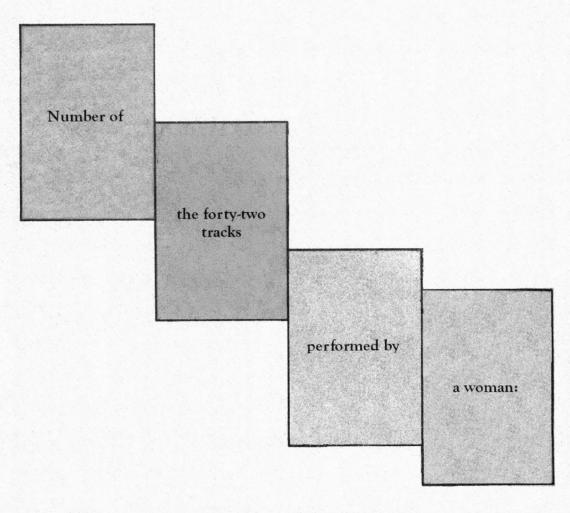

Number of

the forty-two
tracks

performed by

a woman:

one.

THE DOOR
(OUR ARMY AT WAR #22)

No one can touch the Mississippi Sheiks. You need to understand that. Long before their first recordings, they already make a good living playing parties, picnics, night-clubs—anywhere people need to dance.

And they play everything. Waltzes, fox-trots, Tin Pan Alley, jazz, blues. They even play old-time music, but only for those occasional white audiences that demand it.

And if someone requests a song they don't know, you'd better believe Lonnie Chat-man, the band leader, will hurry to pick up the sheet music and teach the song to everybody before the next gig.

The definition of a good band in 1929: giving any crowd exactly what they want. No one can touch the Mississippi Sheiks.

Before a black musician enters the recording studio, he must first cross through...

The DOOR!

In the studio as well, the Mississippi Sheiks give the crowd what they want.

Except, in this case, the crowd consists of a handful of white record executives, and what they want is the *only* thing they want from black artists: Race Records.

In the studio, the Sheiks play the blues.

Rat-a-tat.

How can we possibly understand

that what the Sheiks played in the studio

when these recordings

was not their music,

are all we have?

tat-tat-tat-tat-tat-tat-tat-tat-tat-tat-tat-tat-tat-tat-tat-tat-tat-
tat-tat-tat-tat-tat-tat-tat-tat-tat-tat-tat-tat-tat-tat-tat-tat-tat-
tat-tat-tat-tat-tat-tat-tat-tat-tat-tat-tat-tat-tat-tat-tat-tat-tat-
tat-tat-tat-tat-tat-tat-tat-tat-tat-tat-tat-tat-tat-tat-tat-tat-tat-
tat-tat-tat-tat-tat-tat-tat-tat-tat-tat-tat-tat-tat-tat-tat-tat-tat-
tat-tat-tat-tat-tat-tat-tat-tat-tat-tat-tat-tat-tat-tat-tat-tat-tat-
tat-tat-tat-tat-tat-tat-tat-tat-tat-tat-tat-tat-tat-tat-tat-tat-tat-
tat-tat-tat-tat-tat-tat-tat-tat-tat-tat-tat-tat-tat-tat-tat-tat-tat-
tat-tat-tat-tat-tat-tat-tat-tat-tat-tat-tat-tat-tat-tat-tat-tat-tat-
tat-tat-tat-tat-tat-tat-tat-tat-tat-tat-tat-tat-tat-tat-tat-tat-tat-
tat-tat-tat-tat-tat-tat-tat-tat-tat-tat-tat-tat-tat-tat-tat-tat-tat-
tat-tat-tat-tat-tat-tat-tat-tat-tat-tat-tat-tat-tat-tat-tat-tat-tat-
tat-tat-tat-tat-tat-tat-tat-tat-tat-tat-tat-tat-tat-tat-tat-tat-tat-
tat-tat-tat-tat-tat-tat-tat-tat-tat-tat-tat-tat-tat-tat-tat-tat-tat-
tat-tat-tat-tat-tat-tat-tat-tat-tat-tat-tat-tat-tat-tat-tat-tat-tat-
tat-tat-tat-tat-tat-tat-tat-tat-tat-tat-tat-tat-tat-tat-tat-tat-tat-
tat-tat-tat-tat-tat-tat-tat-tat-tat-tat-tat-tat-tat-tat-tat-tat-tat-
tat-tat-tat-tat-tat-tat-tat-tat-tat-tat-tat-tat-tat-tat-tat-tat-tat-
tat-tat-tat-tat-tat-tat-tat-tat-tat-tat-tat-tat-tat-tat-tat-tat-tat-
tat-tat-tat-tat-tat-tat-tat-tat-tat-tat-tat-tat-tat-tat-tat-tat-tat-
tat-tat-tat-tat-tat-tat-tat-tat-tat-tat-tat-tat-tat-tat-tat-tat-tat-
tat-tat-tat-tat-tat-tat-tat-tat-tat-tat-tat-tat-tat-tat-tat-tat-tat-
tat-tat-tat-tat-tat-tat-tat-tat-tat-tat-tat-tat-tat-tat-tat-tat-tat-
tat-tat-tat-tat-tat-tat-tat-tat-tat-tat-tat-tat-tat-tat-tat-tat-tat-
tat-tat-tat-tat-tat-tat-tat-tat-tat-tat-tat-tat-tat-tat-tat-tat-tat-

When record execs decide a track doesn't sound "race" enough...

The DOOR!

Mississippi Sheiks Recordings Released in Okeh
Records' Hillbilly Series, "Old Time Tunes"

"The Sheik Waltz" (OK 45436)
"The Jazz Fiddler–1" (OK 45436)
"Sheiks Special" (OK 45468)
"Dear Little Girl" (OK 45468)
"Mississippi Low Down" (OK 45482)
"That's It" (OK 45482)
"Jackson Stomp–1,4" (OK 45504)
"Farewell Stomp–1" (OK 45532)
"Vicksburg Stomp–2" (OK 45519)
"Morning Glory Waltz–1" (OK 45532)
"Sunset Waltz–4" (OK 45519)
"Alma Waltz (Ruby Waltz)–1,3" (OK 45504)

On the labels of these records,

Lonnie and Bo Chatman

The whole band becomes

become "The Carter Brothers."

"Mississippi Mud Steppers."

tat-tat-

tat-

tat-tat- tat-tat-

tat-tat-

tat-

tat- tat- tat-tat-

tat- tat-tat-tat-

tat-tat-

tat-tat-

tat-

tat-tat- tat-tat-tat-tat-

tat-tat-tat-

tat- tat-tat-

tat- tat-tat-

tat-tat- tat-

tat-

tat-

tat-tat-

tat-tat- tat-tat-

 tat-

tat- tat-tat-tat-

 tat-tat-

tat-tat-

tat-

tat-tat-tat-

tat-

 tat-

tat-

BLUE YODEL NO. 9
(OUR ARMY AT WAR #22)
(BATTLE STORIES #7)

1) I am told by one of the more assiduous record collectors that he often found

KLANG!

BEEOW!

Mississippi John Hurt records in white homes...

KRUUUMMM

BERR-REEE SZZZZEVRRMMP

Conversely, he tells me that he virtually

KA-WHUMM

BRUMMPFF

WHUMPP

TSZZINNNGG

never found a fiddle hoe down record in a black home,

TAKKATAKKA!

TAKKA! TAKKA-TAKKA!

BRATATATAT!

though he frequently found

Jimmie Rodgers discs.

2) The country singer Jimmie Rodgers, me and Robert

used to play a hell of a lot of his tunes, man.

1) Elijah Wald, music historian

2) Johnny Shines, musician and traveling
companion of

a man who they say sells his soul to the devil in
exchange for his talent,

who records twenty-nine Race tracks to little
sales and near total obscurity before dying of
syphilis, pneumonia, or poison at the age of
twenty-seven,

who is only discovered in the sixties by (white)
(foreign) blues revivalists,

who, according to Shines, plays "anything" he
hears "on the radio... Ragtime, pop tunes, waltz
numbers, polkas,"

"The King of Delta Blues,"

Robert Johnson

3) And then, *my* man, that I dug, that I really *dug*, that got my yodel from,

PLOP!

was Jimmie Rodgers.

See, he yodeled, and I turned it into something more of a howl.

July 16th, 1930. Hollywood, CA. Jimmie Rodgers records "Blue Yodel No. 9" for Victor Records. Accompanying him on trumpet for this session?

SLAP-

Louis Armstrong.

4) Standin' on the corner

I didn't mean no harm...

KPOW! KPOW! KPOW!

3) Chester Burnett

 aka Howlin' Wolf

4) The opening lines to "Blue Yodel No. 9"
 sung by

 a man who they say learns everything he
 knows about music traveling the country as
 a railroad brakeman,

 who records twelve-bar blues, Tin Pan Alley,
 cowboy songs, and slick blends of jazz,
 Hawaiian, and pop,

 all released by Victor Records' Hillbilly series,
 "Old Familiar Tunes and Novelties,"

 Hillbilly, unlike Race, less a restriction of
 sound than a winking fiction that even the
 most modern music, when played by a white
 man with a southern accent and unearthly
 yodel, becomes "Old,"

 who brings in a trumpeter for the recording
 of "Blue Yodel No. 9,"

 "The Father of Country Music,"

 Jimmie Rodgers

5) Many of the songs he sings

do not appear in this volume...

Prime examples are the yodeling

blues and ballads of Jimmie Rogers [sic] of recent fame, whose ardent admirer, Lead Belly still remains.

His favorite song, we hate to say, is

"Silver Haired Daddy."

5) A man who meets convict Huddie Ledbetter
while "collecting" songs at Angola State
Prison,

who, when "collecting" songs, also has a habit
of copywriting them,

who hires Lead Belly, once freed, as driver,
assistant, and then main attraction,

who not only records Lead Belly but books
and manages his live appearances,

in both cases forbidding the playing of
Rodger's "Silver Haired Daddy" or any other
song he labels (commercial) (white)
inauthentic,

who, along with the other folklorists, codifies
authenticity and finishes what the record
execs started,

"The Ballad Hunter,"

John Lomax

Two Diagrams

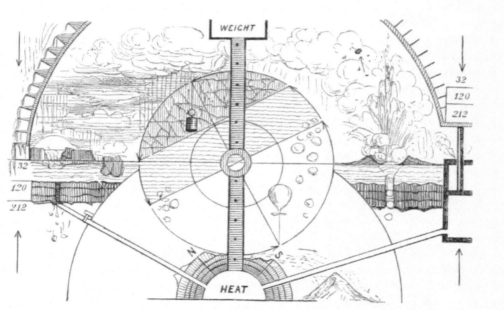

FIG. 62. Diagram of Why You Think I'm Lying

Fig. 128. Diagram of What Remains Unsaid

THE END

NOTES

"Your Favorite Song (Battle Stories)" is particularly indebted to the scholarship of Elijah Wald and Karl Hagstrom Miller. "Your Favorite Song (Battle Stories # 7)" and "The Invention of Difference (Our Army At War # 22)" rely heavily on the vision of music history depicted in Wald's *How the Beatles Destroyed Rock 'N' Roll: An Alternative History of American Popular Music.* The characterization of Hillbilly recordings, "coon shouters," and the Lomax folkloric paradigm derive from Miller's *Segregating Sound: Inventing Folk and Pop Music in the Age of Jim Crow.*

p. 180: Patrick Huber, "Black Hillbillies: African American Musicians On Old-Time Records, 1924-1932" in Diane Pecknold. ed., *Hidden in the Mix: The African American Presence in Country Music* (Durham NC: Duke University Press, 2013), 80. The description of the Sheiks' live repertoire also derives from Huber.

p. 186-187: 1) Elijah Wald, *Escaping the Delta: Robert Johnson and the Invention of the Blues* (New York: Amistad, 2004), 80. 2) qtd. in Wald, 118.

p. 188-189: 3) qtd. in Barry Mazor, *Meeting Jimmie Rodgers: How America's Original Roots Music Hero Changed the Pop Sounds of a Century* (Oxford: Oxford University Press, 2009), 48.

p. 190-191: 5) From the unpublished notes for Lomax's *Negro Folk Songs as Sung by Lead Belly* (1936). qtd. in Karl Hagstrom Miller, *Segregating Sound: Inventing Folk and Pop Music in the Age of Jim Crow* (Durham NC: Duke University Press, 2010), 245.

JOHNNY DAMM is the author of *The Domestic World: A Practical Guide* (Little Red Leaves), *Your Favorite Song* (Essay Press), and *The Old Man's Illustrated Library: Issues # 36 & # 5* (No Press). His work has appeared in *Poetry, Denver Quarterly, The Rumpus, Quarterly West*, and elsewhere. He is editor-in-chief of *A Bad Penny Review* and *Opo Books & Objects*.

Visit him online at
johnnydamm.com.

ACKNOWLEDGEMENTS

Sections of this book have previously appeared in
Chicago Quarterly Review, Covered w/ Fur, The Destroyer, TheEEEL, No Tokens, Poetry, Quarterly West, The Rumpus, Small Po[r]tions, Timber, and in two chapbooks, *The Old Man's Illustrated Library: Issues #36 & #5* (No Press) and *Your Favorite Song* (Essay Press).

My thanks to the teachers and mentors who first provided me with the space and intellectual stimulation to attempt this work: Jed Rasula, Andrew Zawacki, and Ed Pavlic. To Lynne DeSilva-Johnson, for adopting this odd-formed orphan. To my stepfather, Joseph Witek, for giving me a stack of 65-year-old coverless comics that I've been using as building materials in my work for years now, as well as for his knowledge of both comics and music. And to my most supportive readers: my mother, Terri Witek, and sister, Rachel Nelson.

ON SCIENCE

The name of the book comes from a popular nineteenth century science textbook that claims to explain "the common phenomena of life." The actual title of the textbook is *A Guide to the Scientific Knowledge of Things Familiar*, but on the spine of my copy, the title is shortened to *Science of Things Familiar*.

For me, these "common phenomena" are music, film, and (comic) books.

ON MUSIC

In the early nineties, I was a punk rock kid in Central Florida, and from the time I was fifteen until I was twenty, I worked in an amazing local music store. We carried CDs and cassettes but were best known for our deep, deep selection of vinyl. It's not an exaggeration to say I grew up in that shop. I spent most of my time (and money) there, so you might imagine how it felt when the owner picked me, from all the other record nerds and sullen teenagers that daily gathered in the shop, as his sole employee. I still don't know what he saw in me, but that job changed everything.

It was also the start of the project that eventually became "Your Favorite Song (Battle Stories)." Fundamental to the version of punk rock I grew up with (I'd name Fugazi and Bad Brains as the two bands I've listened to the most in my life) are notions of authenticity. It's strange to consider now, but as a teenager, I'd spend an enormous amount of time policing the bands I loved. Any sign that they were too interested in success or that the stories they told came from their imagination rather than their lived experiences and I'd write them off as not ever having been truly punk rock to begin with. When I was fifteen, a band could be my favorite one day and then railed against as sell-outs the next.

Working at the record store, of course, I listened to all sorts of other music as well. I deeply loved, for example, Billie Holiday, Hank Williams, Public Enemy, and Ornette Coleman, but in a sense, this love was dependent on viewing these artists through that same punk rock lens: I considered them authentic. I fully embraced the narrow strictures of authenticity, even as I was also beginning to become suspicious of it.

By the time, years later, that I discovered the work of Elijah Wald, my suspicions had grown into

a general rejection of orthodoxy, including the orthodoxy of my teenage version of punk rock. By this time, I'd begun to recognize the incongruities in songs that I'd once considered gritty and true-to-life. Hank Williams' "I'll Never Get Out of the World Alive," which shot up the charts following the announcement of his death, *sounded* like an eerie prediction of a hardened outlaw—at least until I learned Williams recorded it as a novelty song based on a popular catch-phrase of the comedian W.C. Fields. After reading Wald's *Escaping the Delta* and the work of other music scholars who question orthodox music history, I found that the ultimate source of my suspicions was even more damning than I'd considered. The *racial imaginary*, to borrow Claudia Rankine's phrase, not only dictated what was recorded but also how we *hear* music: the "roots" of US music represent one more facet of the great white supremacist lie.

⊂ɴ Ƒɪʟᴍ

1) The invisible presence still haunting the US film industry is its history as a woman-dominated industry.

2) The first film director, in the sense we now consider the job, was Alice Guy-Blaché, and in the early film industry, women occupied every conceivable role.

3) Women's dominance continued until men began to realize how profitable movies could be—until it became big business—and women were uniformly pushed out from roles of power.

4) Over a hundred years later and here we basically still are.

⊂ɴ ⊂ᴏᴍɪᴄꜱ

My mother is a poet and my stepfather a comics scholar: poetry and comics formed much of the vocabulary of my childhood. In the nineties, any money I had left over from records, I spent on indie comics such as *Love and Rockets, Dirty Plotte, Eightball,* and *Yummy Fur.* I flirted with the idea of writing comics in high school and, at one point, teamed up with an artist friend, to try to write a comic about, if I'm remembering correctly, a handyman who spied on all the residents of an apartment building through holes in the ceiling. Thankfully, we never got any further than a few pages of scribbled notes and preliminary drawings.

Years later, in my first (failed) attempt at a novel, my narrative cut between the story of a comics writer and the story of comic he was writing, a robot murder mystery. In the novel, I spent countless pages describing what the comic book *looked* like. In effect, I was reverse-engineering a visual-verbal medium back into solely a verbal one. There's something I still rather like about this idea (and there are writers who've pulled off something similar) but eventually had to admit

failure. In retrospect, I realize that I was more interested in the *comic-within-the-book* than I was in the *book* itself.

Working with *Classics Illustrated* finally gave me a way to enter back into the comics form. The fact that these comic books were adaptations of (text-only) books, and radically compressed ones at that, gave me some sort of permission. I wanted to take the original books back from the comics and use them for my own purposes: to appropriate the appropriation. In doing so, I'd make the authors themselves, whose original stories maintained at best a ghostly presence in the adaptations, the characters of the new work. I knew before I started that there was some sort of joke here about the formation of a literary canon. Almost the entire run of *Classics Illustrated*, of course, consists of adaptations of books by dead white men. So, there was also something in the mix with the potential to critique white masculinity: decaying masculinity as depicted through decaying comics.

Classics Illustrated gave me permission to make comics, and I haven't slowed down with the work since. Issues of the comic often included an advertisement for a cheap looking three-ring binder. The idea was that you could punch holes in the individual issues of the comic and store your whole collection in the binder. "BUILD YOUR OWN LIBRARY," the advertisement instructed. All I'm doing is following this instruction: I've been using comic books to build my library ever since.

Q&A

WITH OS FOUNDER / MANAGING EDITOR
LYNNE DESILVA-JOHNSON

Science of Things Familiar *will challenge a lot of folks' notion of where the edges of poetry begin and end. In your opinion -- what's a "poet", anyway?*

I just read Anne Carson on this subject: "If prose is a house, poetry is a man on fire running quite fast through it."

Yes! And let's throw in David Antin: "if robert lowell is a poet i don't want to be a poet."

Far better answers than I can give, but let me try to get a little more technical.
Poet: A text-artist whose medium is language—with both "text" and "language" broadly defined.

Clunky, but that's a definition for poet I'm willing to have applied. Any narrower of a definition— anything bringing the term closer to Lowell, I suppose—and I'd prefer to simply be thought of as "writer."